Painting with Pastels

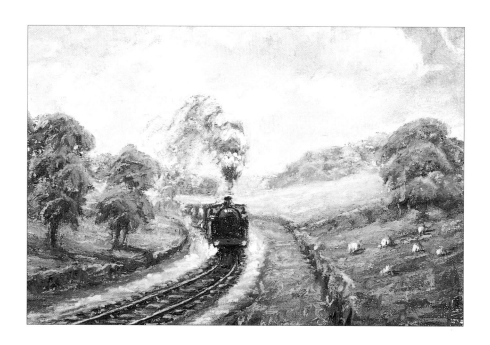

D0012105

To Margaret my wife, and my
three sons Graham, Stephen and
Mark for their critiques.

Painting
with
Pastels

PETER COOMBS

SEARCH PRESS

This edition first published in Great Britain 2012

Search Press Limited
Wellwood, North Farm Road,
Tunbridge Wells, Kent TN2 3DR

Originally published in Great Britain 1999

Text copyright © Peter Coombs 1999

Photographs by Search Press Studios
Photographs and design copyright © Search Press Ltd. 1999

ISBN: 978 1 84448 886 5

The publishers and author can accept no responsibility for any
consequences arising from the information, advice or instructions
given in this publication.

The publishers would like to thank Winsor & Newton for supplying
many of the materials used in this book.

Suppliers
If you have difficulty in obtaining any of the materials and equipment
mentioned in this book, then please visit the
Search Press website: www.searchpress.com

Publisher's note

All the step-by-step photographs in this book feature the author,
Peter Coombs, demonstrating how to paint with pastels.
No models have been used.

Front cover
Quiet Reflections
530 x 405mm (21 x 16in)

Page 1
Steaming Through the Countryside
250 x 170mm (9¾ x 6¾in)

Pages 2–3
Poppies
350 x 260mm (13¾ x 10¼in)

Printed in Malaysia

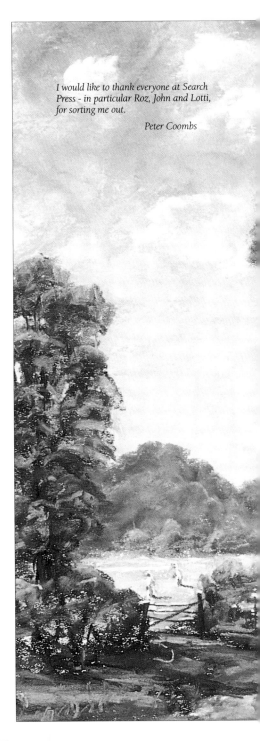

*I would like to thank everyone at Search
Press - in particular Roz, John and Lotti,
for sorting me out.*

Peter Coombs

Contents

A Stroll in the Country
405 x 530mm (16 x 21in)
A landscape scene can often look very effective
when composed in a portrait shape.

Introduction

Pastels are made from finely-ground colour pigments that are bound together with gum and compressed into sticks. The great joy of painting with pastels is the direct and quick way you can transform a sheet of paper into a painting. It is a dry medium, so you do not need special brushes or a supply of water before you start.

Records show that drawings were created with pastels as early as 1685. In fact, many old masters used pastels to create fine works of art that are as fresh today as they were when painted. The popularity of pastels as an artistic medium led to the formation of the Pastel Society in the late nineteenth century, and this continues to thrive today.

In this book I try to dispel the myth that painting with pastels is difficult. Do not worry about whether you can 'draw a straight line' – pastels are very adaptable and, in any case, there are not many straight lines in nature. You can make marks with the pastels and blend colours together with your finger. If you are not happy with the result, you can go over it with other colours.

Everyone develops their own way of painting with pastels. In my mind, there is no wrong way of creating art – so if you get a result that satisfies you it is the right way.

I have included four step-by-step demonstrations to help build up your skills. Take things slowly at first, work lightly and loosely with the colours and you will soon be saying proudly, 'I did that'. So get started and make your marks!

An Evening Stroll
535 x 400mm (21 x 15¾in)
This painting portrays form against light. Note how the depth of tone in the foreground leads you to the figures, the point of interest, and then out to the rest of the painting.

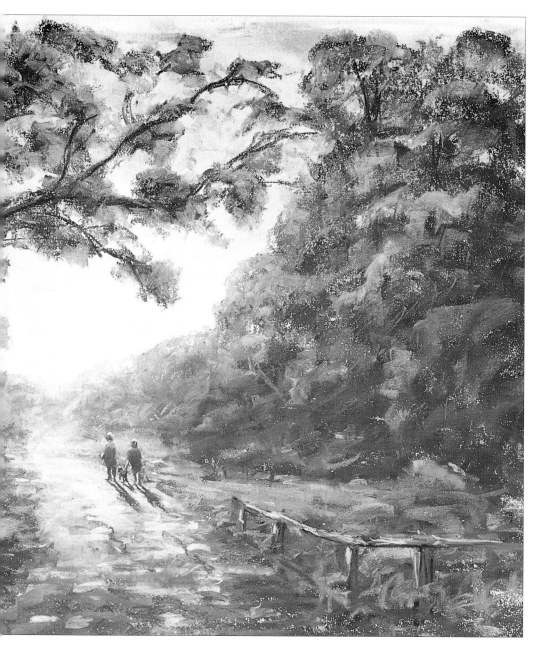

Materials

Painting with pastels need not be an expensive hobby. A few soft pastels, some paper, masking tape and a board are all you need to get started. As you become more experienced you may want to add to this list.

Pastels

Unlike other painting mediums, pastels are dry and cannot be diluted. However, individual colours are usually available in a range of tints. The pastels used in this book have five tints of each colour – tint 4 is the pure colour, tints 3, 2 and 1 are lighter tones and tint 5 is a darker tone. Buy the best pastels you can afford. A few good-quality soft pastels will serve you much better than a wide range of cheaper ones. Some pastels have a lot of binder and do not release colour easily.

Pastels get dirty quite quickly, especially if, like me, you work with them in a tray/box beneath your drawing board. If you want to keep pastels, clean try adding ground rice to the box.

Paper

Use a paper with a 'tooth' or surface texture that will hold the powdered pastel and give a good base on which to build up colour. Pastel paper, in sheet or block form, is available in a variety of colours, textures and weights. More often than not I use a 220gsm white paper but I sometimes use a coloured paper for a particular effect. For large paintings, use pastel board or the white side of mount board. However, if you want to use a large sheet of paper I recommend it be dry mounted on acid-free board to stop it cockling in the frame.

Other equipment

I paint on a wooden board, mounted vertically to allow pastel dust to drop off – an easel is useful but not essential. A small clipboard is useful for field trips.

Use masking tape to secure your paper to the drawing board.

Pastels make your fingers dirty, so use wet wipes or a damp rag to keep them clean. Alternatively, try rolling a small ball of plastic adhesive between your fingers to remove colour.

Spray finished paintings with a light coat of fixative before mounting them under glass.

A lightweight sketching easel is ideal for outdoor or smaller studio work.

My tray is always messy – I am too impatient to get on with a painting to organise my colours before I start. However, I will select the colours I want to use for the painting and place them in a separate box.

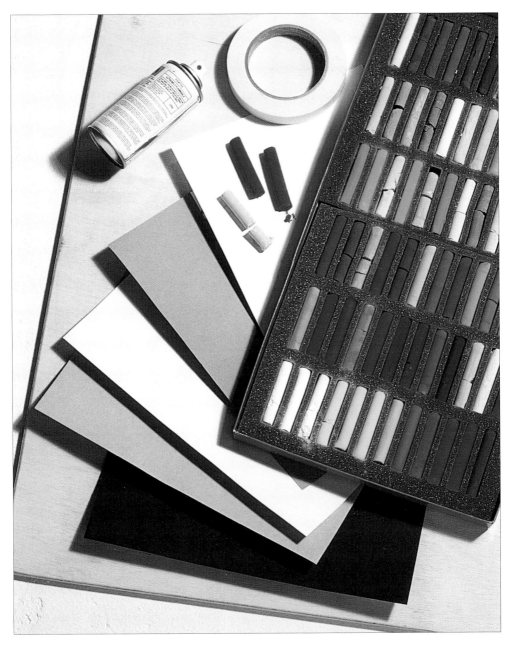

Playing with pastels

Pastels are fun. They are versatile and easy to use, so do not be afraid to play with them. Try out different marks on the paper, work up a technique for creating tone, and experiment with blending tints. Aim to cover the paper with colour as quickly as possible. Do not feel threatened, make your marks and blend them into a work of art!

Making marks

You can use pastels in a variety of ways to make marks on the paper. These initial marks leave tiny concentrations of pure colour pigment in the tooth of the paper, which can then be softened by finger blending. When teaching students, I find that their biggest problem comes from applying too much pressure and, hence too much colour. Even when creating a dense area of colour, it is best to build up the tones layer by layer.

Most marks are made using the side of the pastel flat against the paper, but you can also use the tip of the pastel to produce more defined marks.

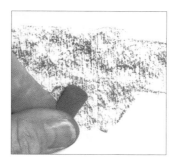

Hold the side of the pastel flat against the paper, and then gently slide it over the surface to create loose, broad strokes of colour.

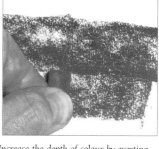

Increase the depth of colour by exerting more pressure. Remember not to cover the paper with solid pigment.

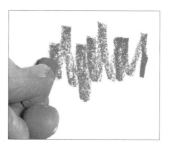

Create a chisel shape on the end of a pastel and drag the end across the paper to create broad strokes of colour.

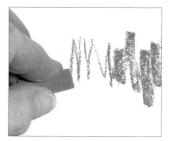

Turn the chisel end of the pastel sideways to create finer lines.

Creating tone

Having made your marks on the paper the fun really begins, and you will soon realize how easy it is to move colour around. Here I show you how to use simple strokes and finger blending to create a beautiful sky. These simple techniques are used for all the paintings shown in this book.

Blending a simple sky

For this exercise, I used two blues and two yellows. The pale blue is Winsor blue (red shade) T1 (tint 1) and the slightly stronger one is cobalt blue hue T2. The yellows are yellow ochre T1 and gold ochre T1. Place the colours randomly over the surface of the paper and then blend them together with your finger to create shape.

1. Use the flat side of the pale blue pastel to lightly apply broad squiggles of colour to the paper.

3. Now work the remaining white areas (the clouds) with a layer of the pale yellow pastel.

2. Lay in a deeper tone of blue using the same stroke, but with slightly more pressure.

4. Then, using very light strokes with the side of the pastel, add a glaze of dark yellow over the other colours.

5. Finally, randomly rub over the colours with a clean finger to smooth and blend them into each other. Work from the centre of the image out towards the edges. Your fingers will get dirty quite quickly, so use wet wipes, a damp rag or some plastic adhesive to clean them regularly.

Colour blending

Although pastel colours are dry, you can create tonal variations by applying colour over colour and then blending them together with your finger. Experiment with colours of your choice and you will soon get the feeling that you are painting, not drawing. Cut across the mixes with a contrasting colour and note how the soft pastel releases pure colour without scraping off the under tones. Here are a few examples of blended colours.

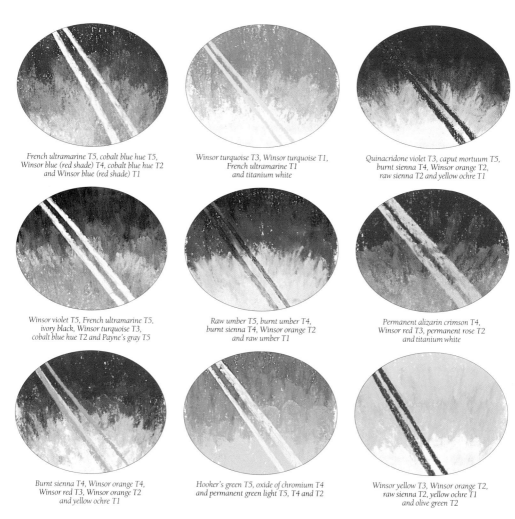

French ultramarine T5, cobalt blue hue T5, Winsor blue (red shade) T4, cobalt blue hue T2 and Winsor blue (red shade) T1

Winsor turquoise T3, Winsor turquoise T1, French ultramarine T1 and titanium white

Quinacridone violet T3, caput mortuum T5, burnt sienna T4, Winsor orange T2, raw sienna T2 and yellow ochre T1

Winsor violet T5, French ultramarine T5, ivory black, Winsor turquoise T3, cobalt blue hue T2 and Payne's gray T5

Raw umber T5, burnt umber T4, burnt sienna T4, Winsor orange T2 and raw umber T1

Permanent alizarin crimson T4, Winsor red T3, permanent rose T2 and titanium white

Burnt sienna T4, Winsor orange T4, Winsor red T3, Winsor orange T2 and yellow ochre T1

Hooker's green T5, oxide of chromium T4 and permanent green light T5, T4 and T2

Winsor yellow T3, Winsor orange T2, raw sienna T2, yellow ochre T1 and olive green T2

Composing a picture

Painting a picture can be quite daunting, even for an experienced artist. Just how do you turn a blank piece of paper into a pleasing three-dimensional image? To my mind, composition is all important. It is not merely a matter of placing unrelated shapes on a piece of paper. A well-composed painting incorporates a number of techniques that combine to catch your attention; to draw your eye to a point of interest (focal point) and then take it out to other elements of the picture. These techniques include choosing a viewpoint, getting the perspective right, changing scale, form and tonal values, using the source of light to good effect, and carefully selecting what you want to include in the painting.

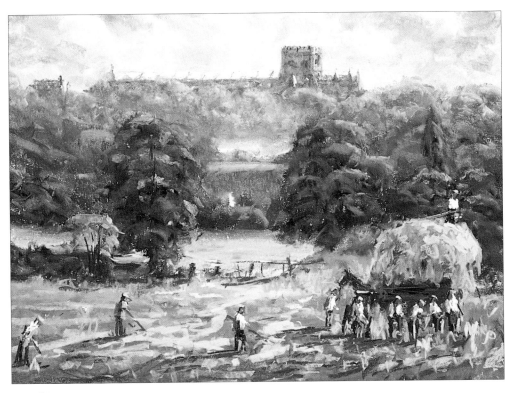

Haymaking
535 x 400mm (21 x 15¾in)

This is an example of what I consider to be a well-composed painting. The illusion of depth is emphasized by the use of rich bright colours in the foreground and cooler tones in the distance. Scale also plays an important part – note the size of the haycart and figures relative to the abbey. Note also how the long shadows of the isolated figures at the left draw the eye towards the right-hand group and then on through the trees to the distant abbey.

Viewpoint

Your view of a scene determines the position of the horizon line. This must always be at your eye level and horizontal to the bottom of the paper. Whether you are standing on flat ground or on top of a hill looking down on a scene, the horizon line will always be level with your eye. You can place the horizon line anywhere on the paper but, generally, an off-centre horizon will improve a composition. The one-third rule works for most subjects – set the horizon one-third up or down from the bottom or top of the paper.

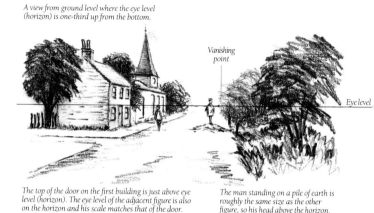

A view from ground level where the eye level (horizon) is one-third up from the bottom.

Vanishing point

Eye level

The top of the door on the first building is just above eye level (horizon). The eye level of the adjacent figure is also on the horizon and his scale matches that of the door.

The man standing on a pile of earth is roughly the same size as the other figure, so his head above the horizon.

Two views of the same scene from different viewpoints.

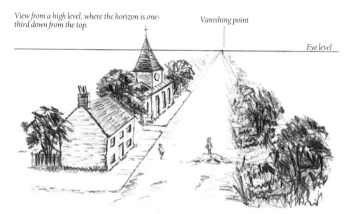

View from a high level, where the horizon is one-third down from the top.

Vanishing point

Eye level

In this view, your eye level is well above that of the figures in the road. The horizon has no on influence the size of the figures, other than to determine their scale relative to the buildings.

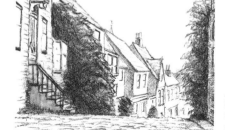

A downhill scene can be a very effective subject. Here, the horizon line aligns with the top handrail on the steps of the house on the left. Although the road goes downhill, all the houses are horizontal, so their roof lines should all meet on the horizon.

14

Linear perspective

The relationship between the horizon level and view point determines linear perspective and scale. There are whole books dealing with perspective, so I will not go into too much detail here. However, there are a few basic rules it is important to understand: objects of similar size must appear smaller the further away they are; buildings must stand upright and not seem to topple over; parallel lines, such as wall and roof lines must converge to a vanishing point. Normally, vanishing points will be on the horizon, but there are exceptions. I have included a couple of sketches to illustrate these basic techniques.

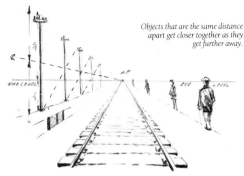

Objects that are the same distance apart get closer together as they get further away.

Lines that are parallel to the horizon remain parallel, and lines that are at right-angles to it converge to a single point on the horizon.

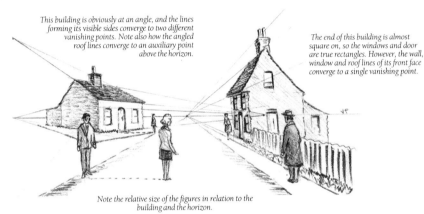

This building is obviously at an angle, and the lines forming its visible sides converge to two different vanishing points. Note also how the angled roof lines converge to an auxiliary point above the horizon.

The end of this building is almost square on, so the windows and door are true rectangles. However, the wall, window and roof lines of its front face converge to a single vanishing point.

Note the relative size of the figures in relation to the building and the horizon.

Form and tonal values

The position of an object in a painting affects the amount of detail (form) needed. Foreground objects need lots of detail to make them realistic. More distant ones are naturally smaller and require much less work to depict them. By varying size and form you create depth, and depth is the essence of good three-dimensional images.

The illusion of depth can also be enhanced by varying the tonal values of colour. Overlay distant objects with cool pale tints of colour and then, as you work forward, gradually introduce darker tints of warmer colours.

Light source

The position and strength of the light source can dramatically affect the composition and mood of a painting. A high bright sun produces short dark shadows, whereas a low setting sun creates long, less dense ones. If you introduce clouds, shadows all but disappear.

Basic elements of a picture

On these pages, I have included some basic elements of a picture – skies, trees, figures and buildings – which demonstrate, in one way or another, the techniques discussed so far.

Skies

In these three skies I show how you can use form and tonal values to create different effects.

These light airy clouds have lots of light tones to indicate a sunny day. Receding tones of warm colours give the illusion of distance.

These heavy storm clouds are overhead and relatively close. Their top edges reflect the available light source and the dark undertones give them form.

Dark colours create this rain-filled sky. Note how lighter tones are intermixed to create depth. The subtle use of lighter colours gives the illusion of gaps in the clouds, through which the sun is trying to shine.

Trees

Trees are an important element of the landscape and, by changing scale, form and tonal values, you can use them to create depth.

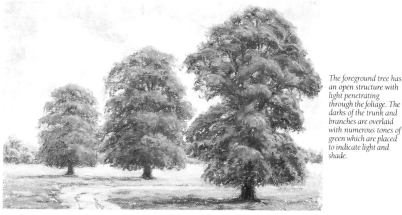

The third tree is so far away that the gaps in the foliage are virtually invisible. Much less form is required, and a pale blue glaze over cool tints of green pushes it right back into the picture.

The foreground tree has an open structure with light penetrating through the foliage. The darks of the trunk and branches are overlaid with numerous tones of green which are placed to indicate light and shade.

The middle distance tree is painted with less attention to detail. Light and shady areas, although still visible, are not so prominent, and the slightly paler tints of green suggest distance.

Figures

It is always a good idea to include a figure or two in a painting – to give an indication of scale and to add a point of interest. People come in all shapes and sizes and they can be painted in a host of situations. In these sketches I try to capture different poses, and to show how to use the available light source to make them significant.

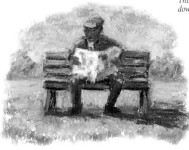

This man's head is inclined downwards to read his newspaper.

Scale affects bulk as well as size. This adult figure is both taller and a great deal heavier than the young child.

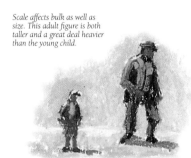

Extensive use of highlights and shadows to give shape and form.

This couple are obviously deep in conversation. The shape of their hair reveals just enough face to turn their heads towards each other.

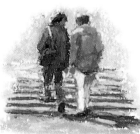

The tonal value of shadow on the steps is most prominent on the nearest one.

Note the similar use of highlights on both figures, and the relative lengths of their cast shadows.

Buildings

Scale and perspective is all-important when depicting buildings. Verticals must be upright, and parallel lines must converge to a common vanishing point.

Distant buildings, such as this church, only need a suggestion of detail to give them form. Here light and shade work together to create the shape of the tower.

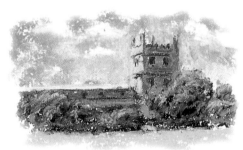

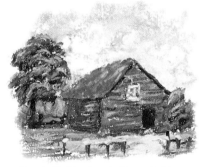

The scale of buildings in rural settings must relate to the surrounding vegetation. The use of uneven strokes gives a rustic look to this wooden barn.

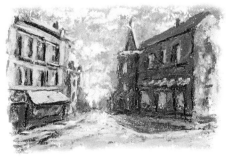

This street scene is a good example of linear perspective. Note also how only one side of the street is in shadow.

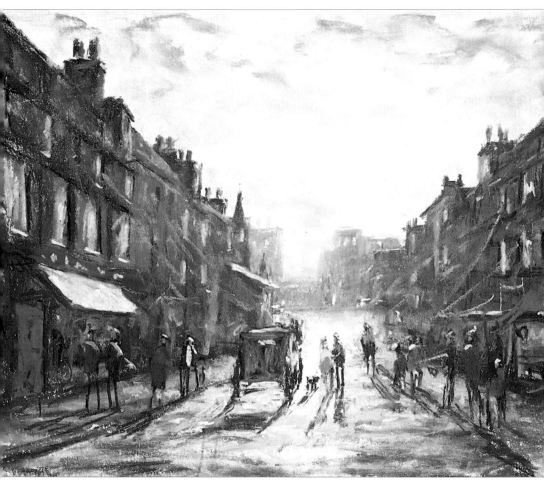

City street
510 x 405mm (20 x 16in)

This busy scene combines the techniques of scale, perspective, form and tone to create a good three-dimensional painting. In terms of scale, all adult figures are roughly the same height but note how they become visually smaller as they move further away. The horizon, about one-third up from the bottom of the picture, represents the eye level of both the viewer and the figures in the painting. The slightly off-centre vanishing point for the buildings is accentuated by the angles of the pavements and roof lines. As the windows get further away, they get narrower and closer together, and less form is required to define the structures. In the background, simple blocking suggests distant buildings, and the cool glaze over them contrasts well with the strong brighter tones of the foreground.

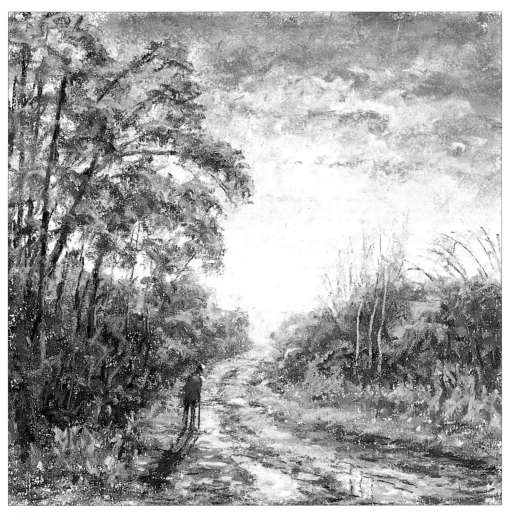

Puddles
205 x 205mm (8 x 8in)

The low angle of the evening sun creates interesting colours in the sky (which are reflected in the foreground puddles) and long, angled shadows. Note how this back lighting produces highlights on the head and shoulders of the figure.

19

Using a limited palette
Landing the Catch

You do not need a wide range of colours to create a painting, and here I show you how effective a limited palette can be. Working with just a few colours will develop your sense of tone.

This seascape shows a fisherman returning with his catch after a night's fishing. The subdued colours of early morning combine with the stormy clouds to make this an excellent subject for a limited palette. For this demonstration I used an A4 (8¼ x 11¾in) sheet of 220gsm white pastel paper and six pastels – black and white, and four tints. Black is used as an underlay for the dark areas, whilst white is used to vary the strength of colour created by the pastel tints, and to create highlights.

A pencil sketch of the subject will help determine the tonal strengths required. Start with a few lines to indicate the main shapes and their vanishing points, and then add light and dark tones to reflect the direction of the light source.

Pastels
Ivory black
Titanium white
Burnt umber T5
Raw umber T5
Payne's gray T3
Winsor red T5

1. Outline the picture area, mark the light source and draw in an horizon line approximately one third up from the bottom. Use the side of the titanium white pastel and broad, light strokes to coat the whole surface of the paper.

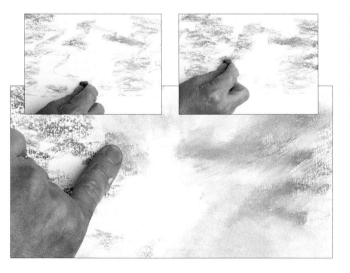

2. Lay in squiggles of burnt umber over the sky, leaving an area for the light source. Overlay these with Payne's gray, then use a clean finger to blend the two colours into each other – work the finger strokes outwards from the central light source.

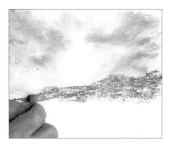

3. Use Payne's gray and light strokes to shade in the shape of the distant hills.

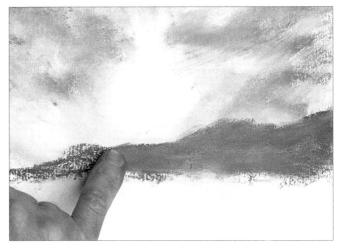

4. Overlay the gray with burnt umber, then fingerblend the colours together.

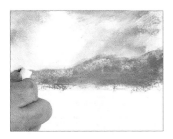

5. Still working lightly, so as not to overwork the colours, use titanium white to lay in highlights on the top of the hills. Blend these into the base colours, following the contours of the hills.

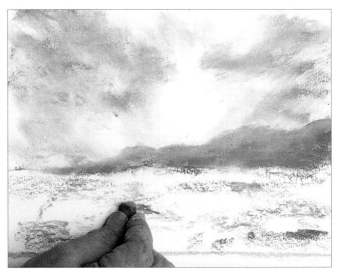

6. Now use burnt umber and more light strokes to suggest the surface of the sea. Leave some areas white to reflect the sky. Work slightly heavier strokes (and hence deeper tones) into the foreground area. Blend the brown into the titanium white base coat, pushing some of the colour back to make weaker tones in the middle distance.

21

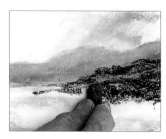

7. Work the basic shape of the middle distance headland using broad strokes of ivory black.

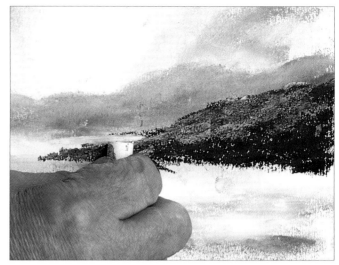

8. Lay a coat of Payne's gray over the black, then a layer of burnt umber. Use the tip of the pastel to add titanium white highlights along the top of the headland.

9. Create shape and form on the headland by gently rubbing a Payne's gray pastel over the whole area to blend all the colours together. Use a variety of strokes and lift the back end of the pastel to make small marks.

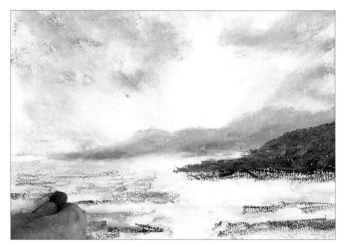

10. Now start to work texture into the sea using raw umber. Apply heavy dark strokes of colour in the foreground, then gradually work back into the distance with lighter, softer touches of colour.

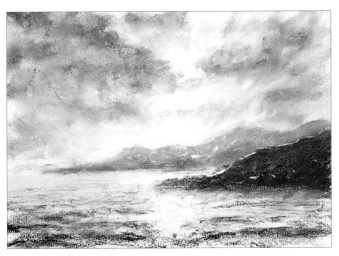

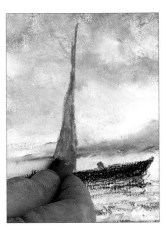

11. Continue to work up the sea and sky, remembering that water reflects the colours in the sky. Use burnt umber to emphasize shadows and the darker foreground areas. Use raw umber and titanium white to create distance and a highlighted area reflecting the light source. Add more burnt umber to the sky to balance the colour of the sea.

12. Use Payne's gray to create the hull of the boat. Overcoat this with ivory black and add the reflections of the hull on the water. Use burnt umber to define the hull and to lay in the mast, sail and the lone sailor.

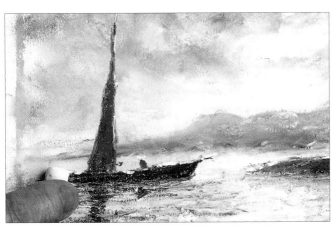

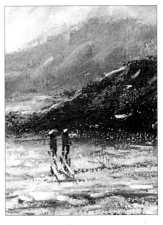

13. Use raw umber and ivory black to add tone to the sail and the reflections of the boat. Add some Winsor red to the sail and its reflection, and a touch to the sailor and his reflection. Add titanium white highlights to the top edges of the boat and its mast and to the sailor's head. Glaze titanium white across the sea.

14. Add two figures to create scale. Use raw umber, overlaid with Winsor red. Highlight their heads with titanium white.

23

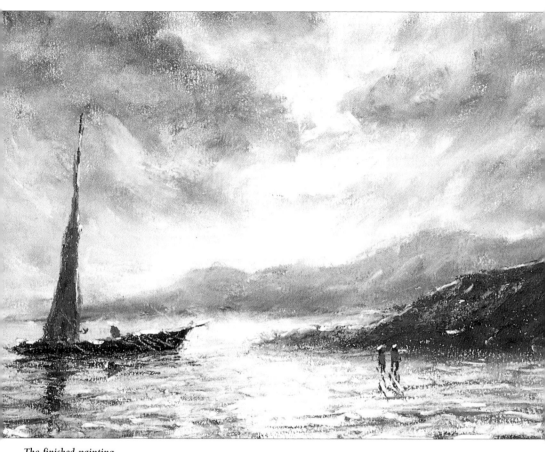

The finished painting

The overhead light is reflected in the dancing waves and the other images in this simple seascape, adding life and a wonderful feeling of movement to the picture.

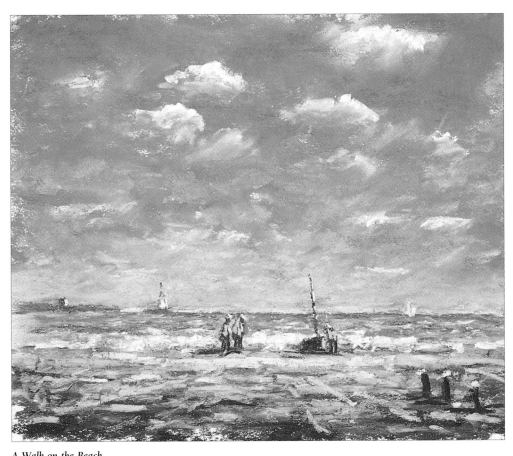

A Walk on the Beach
230 x 200mm (9 x 7¾in)

In this example of a limited palette painting I used six bright colours to create the feeling of a large vista. Compare this to the picture opposite which was painted with more sombre colours.

Painting landscapes

Country Lane

A landscape scene usually has a wide vista with a distant horizon. It should give the illusion of great depth, and scale, perspective, form and tonal values should be used to help achieve this. Although you can create amazing paintings with a limited palette, I generally use a wider range of colours for landscapes – some pale tints to cope with distant tonal values, and stronger tints of brighter colours to bring the foreground closer and to add fine detail.

In this composition, the foreground detail draws you into the focal point, which is the figure walking his dog along the lane. The long shadow of the tree takes you across to the building on the right and its perspective leads you to the distant hills.

I used the smooth side of an A4 (8¼ x 11¾in) sheet of 220gsm pastel paper for this demonstration. Before starting to paint, I outlined the picture area, dotted in the horizon line and marked the source of light (see page 20).

This initial pencil sketch clearly shows the tonal differences between the light and dark areas created by a relatively low light source from the right-hand side of the picture.

Pastels

Cobalt blue hue T1, 2 and 5
Winsor blue (red shade) T1
Winsor yellow T3
Yellow ochre T1
Gold ochre T1
French ultramarine T1 and 5
Payne's gray T3 and 5
Permanent sap green T3
Permanent green light T5
Raw sienna T2 and 3
Oxide of chromium T4
Raw umber T1, 2 and 5
Burnt umber T5
Winsor red T5
Winsor orange T2 and 5
Titanium white
Ivory black

1. Use a mix of cobalt blue hue T2, Winsor blue (red shade) T1, gold ochre T1 and yellow ochre T1 to develop the sky area. Apply the pastel randomly, then gently blend and merge the colours as shown on page 11. Apply French ultramarine T1 to the lower sky. Highlight the clouds with titanium white, blending the colour downwards.

2. Use Payne's gray T3 to block in the distant hills above the horizon, then add depth to them with some Payne's gray T5 followed by a layer of cobalt blue hue T5. Lighten the hill tops with cobalt blue hue T2 – this will make them recede into the distance. Work permanent sap green T3 into the lower hills to suggest foliage. Blend all the colours together then glaze cobalt blue hue T1 across the top of the hills.

3. Define the group of middle-distant trees with raw umber T5. Push cobalt blue hue T5 across the brown to make the trees recede slightly. Apply a touch of permanent green light T5 across the top of the trees, then pull the colour downwards to soften the edges. Blend the colours to create form, then glaze permanent sap green T3 across the trees to suggest highlights in the foliage.

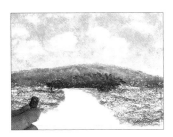

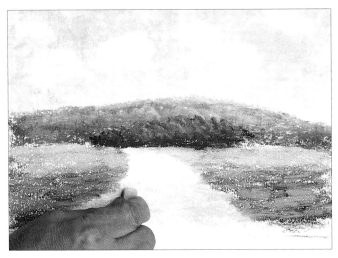

4. Use yellow ochre T1 to colour the surface of the country lane, then block in the remaining white areas with burnt umber T5. Now that all the paper has been covered with colour, the picture takes on a feeling of perspective and realism. Note how the lane leads the eye to the shady woods and on to the distant hills.

5. Work up the foreground area, gradually increasing the size of stroke and depth of colour as you come forward. Start with permanent sap green T3 and then, as you get closer, use raw umber T5, overlaid with oxide of chromium T4. Emphasize the foreground of the lane with raw sienna T3. Start to merge all the colours together.

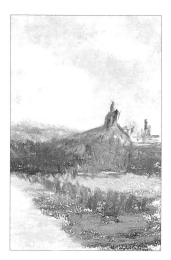

6. Roughly block in the shapes of the buildings, walls and fences using burnt umber T5. Push the pastel into the base colours.

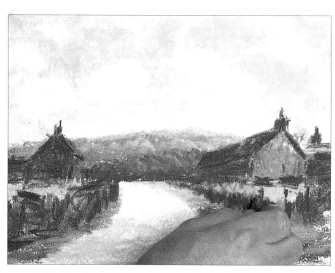

7. Redefine the shapes of the buildings with raw umber T5. Work on the perspective of the roofs, walls and fences. Add shadows as necessary, and allow lighter areas to peep through.

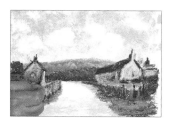

8. Block in the tree behind the left-hand building with Payne's gray T5, and use the same pastel to overlay the right-hand wall. Overpaint the walls of the buildings with raw umber T2. Using the light source as a reference, add reflected light and highlights with raw umber T1.

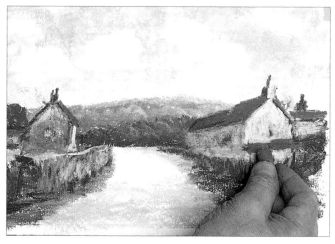

9. Again, bearing in mind where the light is coming from, use Payne's gray T3 to add shadows to the front of the right-hand building and to the end of the left-hand building. Tone these areas down with raw umber T1 and cobalt blue hue T2. Redefine the roofs with Winsor red T5 and then use the same pastel to add detail to the chimney pots.

28

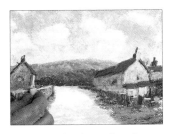

10. Highlight the roofs and chimneys with touches of Winsor orange T5. Use raw sienna T2 to add texture to the end of the right-hand building, to the front of the left-hand building and to the tops of the garden walls.

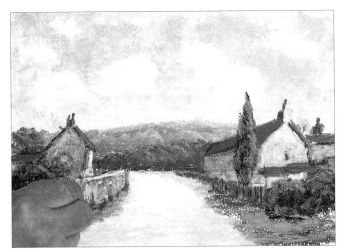

11. Block in the foreground bushes and the tall tree with ivory black. Soften these shapes with raw umber T5, then work texture into them with oxide of chromium T4, allowing some darks to peep through. Glaze permanent green light T5 over the foliage to create texture.

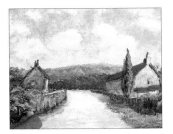

12. Add highlights to the trees, bushes and foreground grass with Winsor yellow T3. Build up shape and form, working the yellow into the other colours. Use raw umber T5 and raw sienna T3 to add the foreground fence. Highlight its top edge with the tip of the pastel.

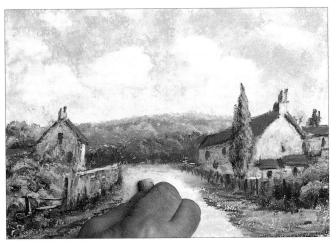

13. Use Payne's gray T3 to paint windows and doors on the buildings, and shadows under the eaves. Apply raw umber T5 over some of the windows and use the same pastel to give form to the edge of the lane. Use French ultramarine T1 at the far end of the lane to create depth. Merge this colour into the middle distant group of trees.

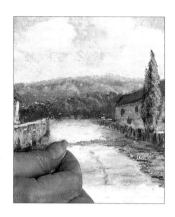

14. Add detail to the lane with raw umber T5 and Winsor orange T5. Blend Winsor orange T2 and yellow ochre T1 into the lane to create a focus of light. Draw in the shadow of the tree using Payne's gray T3 and 5.

15. Block in the figure and his dog with raw umber T5. Add detail with French ultramarine T5 and Winsor red T5, and highlights with cobalt blue hue T2 and Winsor orange T2.

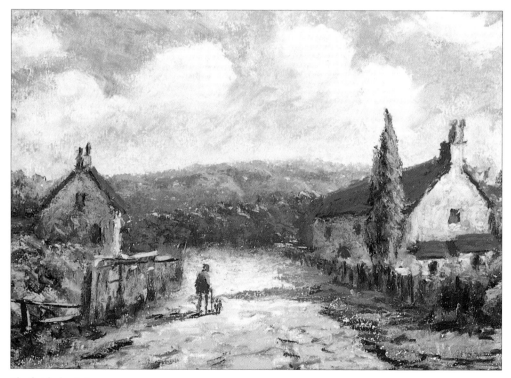

The finished painting
All the shapes and tones have been refined and more highlights have been added. The mixture of greens fading to blue in the distance, and the contrast between the bright foreground colours and the more muted ones in the background add wonderful depth and perspective.

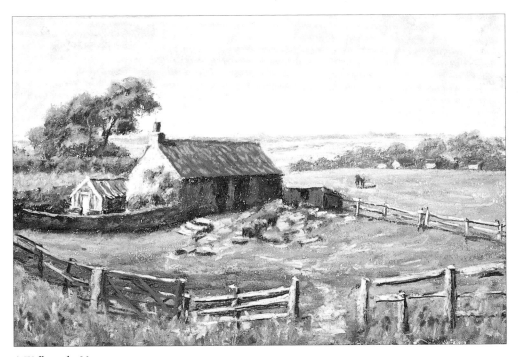

A Walk on the Moors
240 x 160mm (9½ x 6¼in)

In this scene, the opening in the front fence invites you into the foreground paddock. The eye is then drawn to the cottage, out to the two figures and, finally, into the far distance. Note the difference in scale of the cottage to the distant houses at the right-hand side.

Painting water

By the River

Although water is regarded as colourless, it acts like a mirror and reflects the available light and colours. A painted image of water, whether it be sea, river, lake or even a small puddle, must relate to its location and to the influence of the elements such as wind, sun and rain. Smooth water on a lake, for example, creates a mirror image of the background, including the sky. Disturbed water will still reflect background images, but these will be broken with highlights reflected from numerous other parts of the vista.

In this autumnal scene I have tried to capture the movement of river water. The river is quite deep and although the water flows along a leisurely rate, it is still fast enough to ruffle the surface slightly and distort the reflections. Compare this with the water surfaces featured in other paintings in this book (see pages 19, 24, 25, 40 and 48).

The pastels used for this demonstration include a number of warm, rich colours to emphasize the season. The use of bright, violet tints for the flowers on the near bank makes the rest of the painting recede into the background. I painted the picture on an A2 (23½ x 16½in) sheet of 220gsm pastel paper.

The initial pencil sketch. The light source, at the top left of the picture, determines where the light and dark areas should be placed.

Pastels

Winsor yellow, T3 and 4
Winsor red, T5
Indian red, T1 and 2
Winsor blue (red shade) T1
Winsor turquoise T1
Cobalt blue hue T2 and 4
French ultramarine T5
Winsor orange T4 and 5
Payne's gray T3
Raw umber T2, 5
Raw sienna T3
Ivory black
Permanent green light T5
Permanent sap green T3
Hooker's green T5
Quinacridone violet T2, 3 and 5

1. Mark the position of the light source (a late afternoon sun), then use cobalt blue hue T2 to outline the picture area. Place the horizon line one third up from the bottom of the picture, then lightly sketch in the shape of the distant hill.

2. Scribble in the sky using Indian red T2, Winsor orange T5, Winsor turquoise T1, Winsor blue (red shade) T1 and cobalt blue hue T2. Push the colours into each other, then finger blend them together.

3. Add more cobalt blue hue T2, to break up the cloud shapes and reduce their scale. Add Winsor turquoise T1 to the lower left sky area, then Indian red T2. Use the flat side of the pastel to increase the colour, and the tip of the pastel to create highlights. Continue blending the colours to define larger clouds towards the top of the picture. Create perspective in the sky by smoothing out the colours as you work down to the horizon.

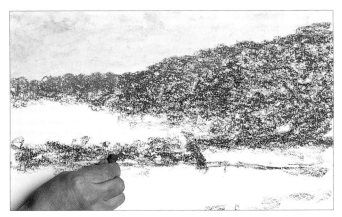

4. Block in the distant hills with Payne's gray T3. Then use the flat side of the pastel to scribble raw umber T5 into the wooded area in the middle distance. Define the banks of the river with the same colour and site the end of the far bank with a darker stroke.

5. Scribble French ultramarine T5 over the Payne's gray on the distant hills and then use it selectively to create deep shadows over the wooded areas that are blocked in with raw umber.

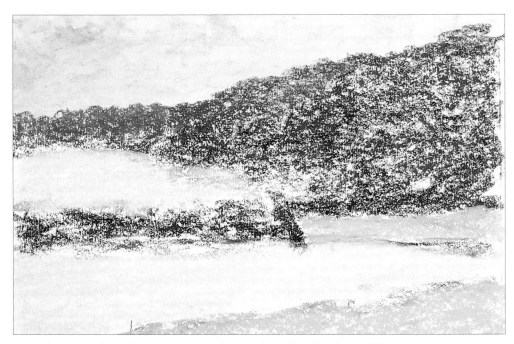

6. Block in the surface of the river and the field on its far bank with Indian red T2. Block in the distant bank and the foreground area with raw sienna T3.

8. Scribble French ultramarine T5 over the Indian red on the surface of the water and use raw sienna T3 over that on the far bank. Overlay the base colour of the foreground area with ivory black and then add a layer of raw umber T5. Use raw umber T2 to add form to the distant riverbank and to add more colour to the field on the far bank.

7. Fingerblend the colours in the blocked-in areas, mixing and moving the pigment around to create shape and form.

9. Start to create depth and perspective in the middle and far distant areas. Work permanent green light T5 into the blocked-in wooded areas, leaving some dark areas exposed – use the flat side of the pastel for soft marks, and its tip for highlights. Apply permanent sap green T3 to the field on the far bank, increasing the tone as you come forward. Add Winsor turquoise T1 to the distant hills and glaze over this with Indian red T2 to add a touch of warmth. Fingerblend the colours, leaving some hard edges.

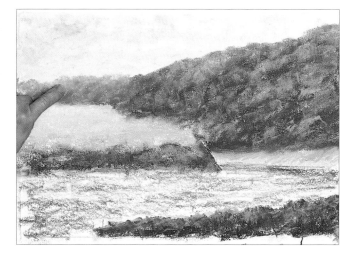

10. Work French ultramarine T5 into the darker areas of the woods to create shadows and texture. Create highlights with Winsor orange T5 and T4, pushing the colours into the greens. Use Winsor yellow T4 to increase the intensity of the highlights on the near trees, softening the edges as you work. Build up the far riverbank with browns and yellows. Continue to build up the trees, working in more colour and blending to define the shapes. Use the same colours to add a little warmth to the near field and the foreground.

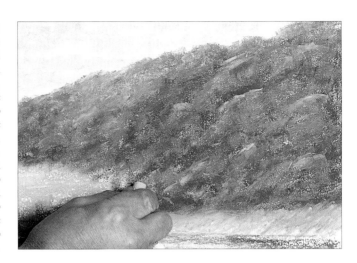

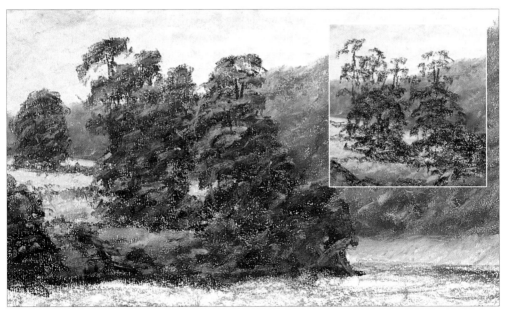

11. Block in the structure of the trees on the far bank with ivory black. Work raw umber T5 into the black areas to tone down the colour and then use permanent green light T5 to start to define the foliage. Glaze cobalt blue hue T4 over the distant tree and shrubbery to push them back into the distance.

12. Now use Winsor red T5 and touches of Winsor orange T5 to add highlights to the tree tops. Add more colour to the centre of the trees to create form. Add small highlighted areas with Winsor yellow T4. Lightly glaze the colour across the far field, dragging the colours into each other. Add highlights of Winsor yellow T3 to the distant trees.

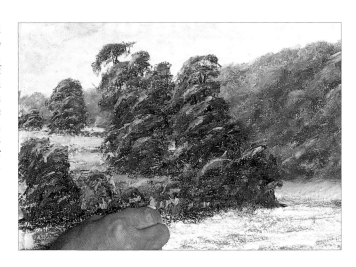

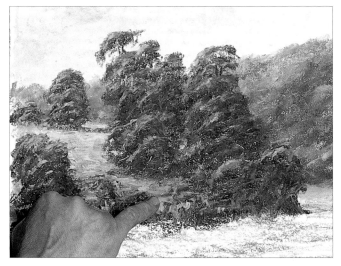

13. Use Hooker's green T5, to define the darker areas on the far bank, softening the black and deep browns. Blend the colour into some of the highlighted areas. Add vertical lines of colour on the riverbank. Use Winsor yellow T4 to blend more highlights over the field and foliage, emphasizing the light and shade. Bring out the lighter foreground areas using permanent green light T5 and T3.

14. Add French ultramarine T5 to work up the colour tones in the water. Apply the pastel with horizontal strokes, following the flow of the water. Glaze Winsor red T5 across the surface of the water to reflect the warmth of the sky. Continue to build up water tones using raw umber T5 in the dark areas and cobalt blue hue T2 and Indian red T1 to reflect the lighter sky colours.

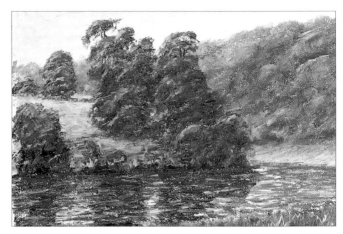

15. Use raw umber T2 and T5 to reduce the brightness of the far riverbank. Add shadows to the upper area beneath the trees, leaving a narrow band of light at the water's edge. Add raw sienna T3 to the lower edge. Glaze French ultramarine T5 over the bank and add subtle shadows to break up the hard line at the water's edge.

16. Add the shadows of the trees across the water using ivory black and raw umber T5. Add reflected lights with Winsor orange T5 then push small areas of French ultramarine T5 into the reflections. Glaze some areas with cobalt blue hue T2 and Indian red T1. Alternate the colours to create movement on the surface of the water.

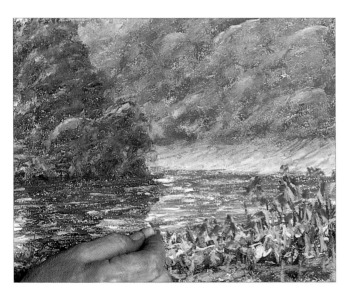

17. Use strong vertical strokes of ivory black, raw umber T5 and Hooker's green T5 to build up colour and texture on the near foreground riverbank. Use a mixture of greens, oranges and yellows to paint in the flower heads and grasses. Add in the wild flower heads using short vertical strokes of quinacridone violet T2, 3 and 5.

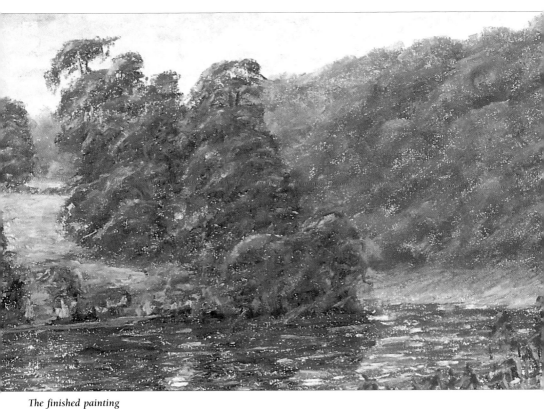

The finished painting

All the colours have been blended further and a focal point (a footpath down to the water's edge) has been added to the far riverbank.

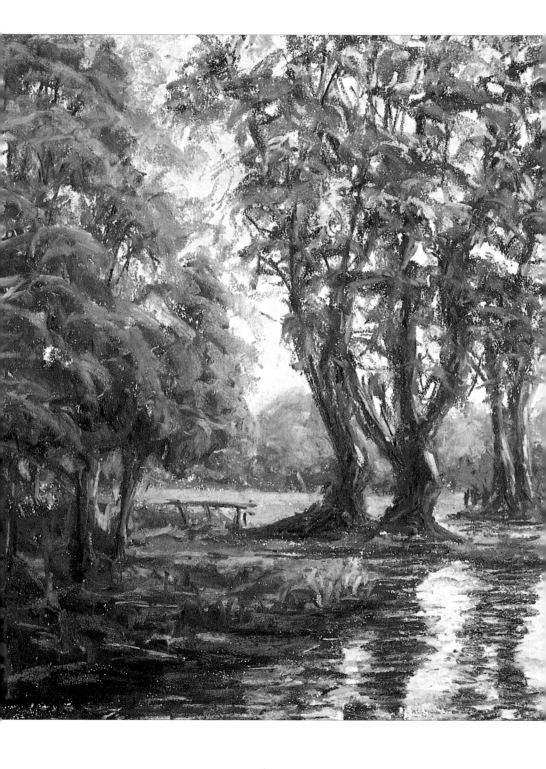

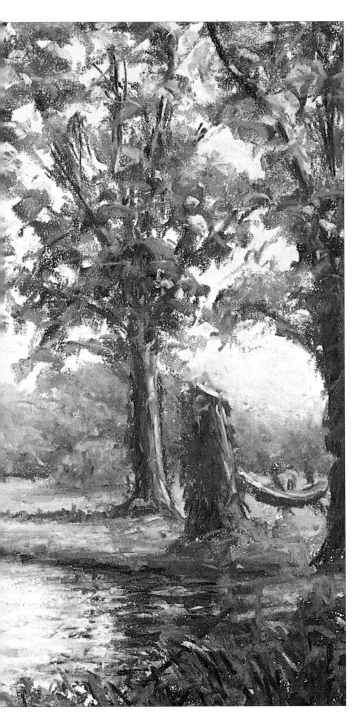

Quiet Reflections
530 x 405mm (21 x 16in)

The almost still water in this painting mirrors the shape of the trees in the background. Note that, although the light is coming from the right-hand side, the reflections are at right-angles to the horizon. The colours in the water also reflect the light colouring of the sky and the darker tones of the foliage overhead. Subtle, horizontal strokes of pastel create this quiet water. You need to paint with more verve, using freer strokes, to create wwa rough, windswept sea.

41

Creating atmosphere

Moonlit Stroll

All paintings should suggest an atmosphere or mood: compare the dark stormy clouds and sombre tones in the seascape on page 24 with the bright, clear sky and strong warm colours used for the river scene on page 39. These two distinct moods relate to weather conditions, but atmosphere can also suggest action or movement (see pages 47 and 480), or a particular time of day as in this demonstration.

For this moonlit street scene a tinted paper will help to 'get you in the mood' right from the start. Here I use a blue-grey tint of 170gsm pastel paper. The colours used are mostly strong tints of dark colours, but some weak tints that are used to paint the moon, are also glazed over the darks to create a diffused luminous effect.

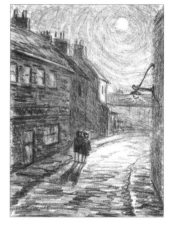

The pencil sketch gives a loose idea of the shapes of the buildings. The position of the moon (the primary light source) determines the placement of highlights and shadows.

Pastels

Cobalt blue hue T4 and 5
Winsor turquoise T1, 3 and 5
French ultramarine T4 and 5
Winsor blue (red shade) T4
Payne's gray T3 and 5
Ivory black
Raw umber T5
Caput mortuum T5
Hooker's green T5
Winsor yellow T3
Winsor orange T3
Quinacridone violet T3 and 5
Titanium white

1. Outline the picture area, draw in the horizon and mark the primary light source. Scribble a base coat of Winsor turquoise T3 over the sky and road areas.

2. Darken the sky with French ultramarine T4 and cobalt blue hue T5, then fingerblend the colours together.

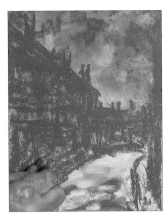

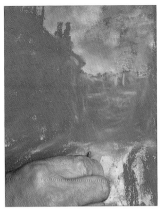

3. Use more French ultramarine T4 to emphasize the dark areas at the top of the sky and to bring the road forward. Lighten the lower part of the sky with Winsor turquoise T3. Blend all colours.

4. Use strong strokes of Payne's gray T5 to block in the buildings and shadows, then merge the pigments to provide a solid undercoat of colour.

5. Push Winsor blue (red shade) T4 and Winsor turquoise T3 into the far buildings to create depth. Add touches of turquoise to the far end of the left-hand building and to the road.

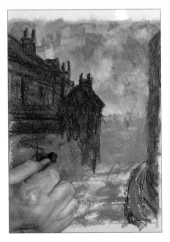

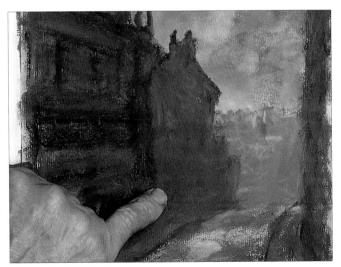

6. Use French ultramarine T4 to overlay the Payne's gray of the left- and right-hand buildings, and to add darks areas in the road. Use ivory black to create shape and structure to the buildings.

7. Blend the black, then push some cobalt blue hue T4 over the far building on the left to suggest reflected light. Work raw umber T5 into the buildings on both sides, and into the pavements and road. Blend the colours to remove hard edges.

43

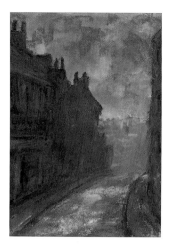

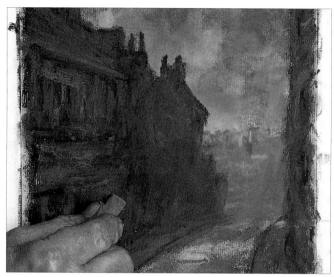

8. Redefine the structure of the foreground buildings using French ultramarine T4 and ivory black. Use French ultramarine T5 to add detail.

9. Use caput mortuum T5 to add light tones to the foreground buildings. Blend these light colours into the dark ones.

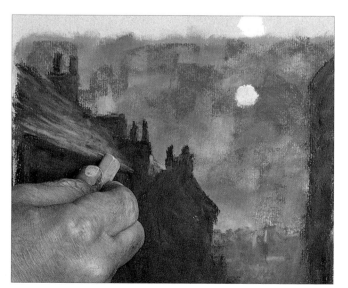

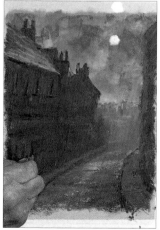

10. Paint in the moon using Winsor turquoise T1, then add reflected light to the roof of the foreground building using T5.

11. Use cobalt blue hue T5, raw umber T5 and Payne's gray T3 to define the architectural detail of the foreground buildings. Push the same colours into the road.

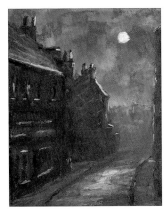

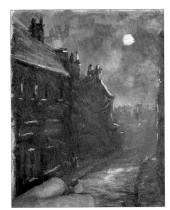

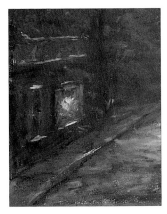

12. Use Winsor turquoise T1 to add highlights to the road, roof edges, chimney pots and windows. Use Winsor turquoise T3 to add more light to the road and to overlay the highlights on the lower windows.

13. Glaze Winsor turquoise T3 over the front of the foreground building to suggest reflected light. Push ivory black into the road and overlay with French ultramarine T5. Redefine highlights with Winsor turquoise T3.

14. Paint the glass windows with Hooker's green T5. Paint a lamp with Winsor yellow T3 and Winsor orange T3 and add reflections on the sill and pavement. Paint the sign with quinacridone violet T5 and T3.

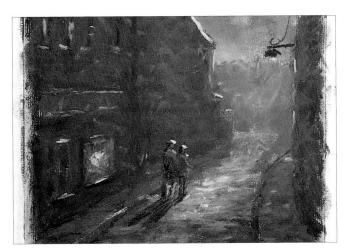

16. Use Winsor yellow T3 to paint the lamp and its reflection on the pavement, and to add indications of illuminated windows in the distant buildings. Use Winsor turquoise T1 to highlight the lamp bracket and to soften the moon.

15. Use the tip of an ivory black pastel to add the lamp on the right-hand building, then block in the two figures and their shadows. Use cobalt blue hue T5, raw umber T5 and Hooker's green T5 to colour their clothing, and then ultramarine T4 and a little caput mortuum T5 to define shape. Add highlights of titanium white.

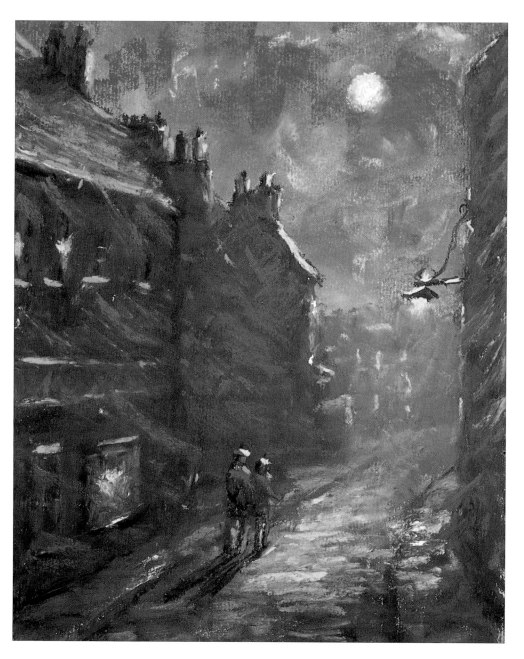

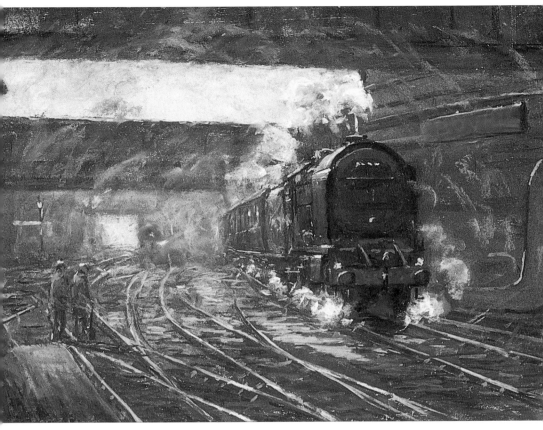

All Fired Up
560 x 405mm (22 x 16in)

This scene is full of atmosphere. The locomotive is definitely on the move, pumping steam and smoke into the semi-underground section of track. This movement is accentuated by the stillness of the two figures watching the train go past. Note how the steam and smoke combine to produce a hazy effect over the solid structure of the walls and bridges. Note also how the available light defines the top surfaces of the track and produces a bright area to draw the eye into the painting.

Opposite

The finished painting

More colours have been used to add depth and tone, light and shade. The moon shines down on to the scene, creating both subtle and bold highlights on the figures and buildings. The street lamp and shop window are secondary sources of light that illuminate some areas of the road and throw the adjacent walls into deeper shadow. These contrasts add a touch of drama to the scene. A final glazing of blue across the painting creates a feeling of atmosphere around the two figures as they walk into the distance.

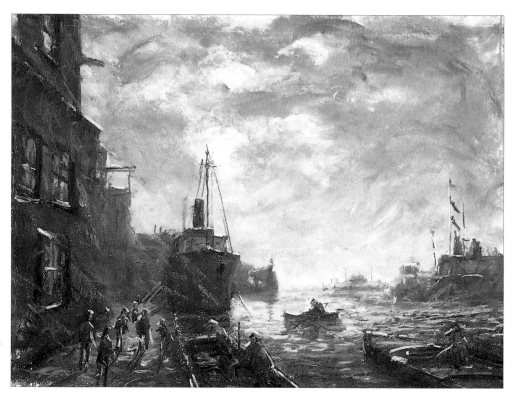

Index

Waiting for the Tide
530 x 420mm (21 x 16½in)

*Back lighting and the use of dark tones
create atmosphere in this dockland
scene. Highlights help identify the
figures, and the foreground barges lead
the eye to the off-centre focal point – the
small boat moving towards the quay.*